YEAH, RICHARD
RA AND I USED
ANG OUT, WE
E GOOD
INDS. I WAS
RE WHEN HE
HIS FIRST
D SPLASH.
WAS REALLY
THING. IT ACTUALLY
ASHED ON ME
VED THE HELL
OF MY SKIN
R MY LEFT
NEY. OF COURSE
BURNIN
M OUT FROM
E INSIDE
SELF NOW.
HA, HA, NO
SERIOUSLY
WERE GOOD
DDIES. I HAVE
AY THOUGH
T A COUPLE
PIECES I'VE
N FROM
LATELY
PRETTY
SE TO
ME OF THE
NGS I HAD
NG IN MY
DIO BACK
THE SEVENTIES.
ED TO HAVE
UDIO IN 142
EEN ST. GET
S $84.90
WAS MY
CKIN RENT
K THEN NOW
CAN'T WETA..

GUSANO
ROJO

BUT SERIOUSLY I DON'T
KNOW WHAT I'D DO
WITHOUT FANELLI'S
HERE. IT'S THE ONLY
PLACE I CAN GO IN SOHO
AND NOT FEEL LIKE AN
OUTCAST. I'VE SEEN
SO MANY OF YOU YOUNG
ARTISTS COME AN GO.
YOU ALL COME IN HERE
ALL ENERGETIC AND
WIDE EYED YOU
THINK YOU GOT IT
UNDER CONTROL
JUST WATE
FIVE YEARS
YOU'LL STILL
BE SWINGIN
THAT HAMMER
ON SOME DIRTY
CARPENTRY JOB
AND YOU'LL GO
RUNNIN BACK
TO NEW ENGLAND
AND BEG YOUR
DADDY FOR A JOB
IN HIS COMPANY.
YOU DON'T FOOL
ME. I'VE SEEN
THOUSANDS OF YOU.
YOU LITTLE SHIT,
WHAT MAKES YOU
THINK YOU'RE ANY
MORE OF AN ARTIST
THAN I. I WAS DOWN
HERE DOING IT WHEN
YOU WERE STILL SUCKIN
YOUR MOMIES TITS.

©1990 Sean Landers

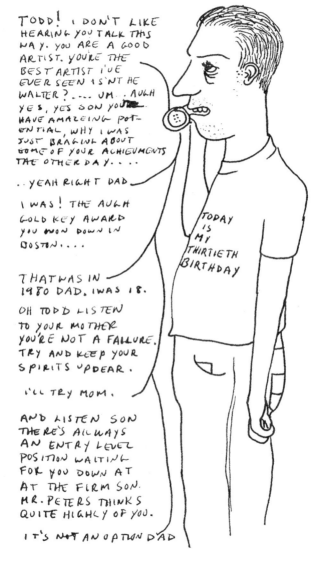

OH YEAH, I HAD A STUDIO VISIT WITH HER TOO.. IS SHE STILL IN TOWN? SHE DID MENTION THAT SHOW, IN MAY RIGHT? OH YOUR IN IT? ... WELL I DON'T KNOW IF I AM OR NOT, SHE DIDN'T SAY ANYTHING ABOUT ME TO YOU DID SHE? ... SHE WAS HARD TO FIGURE OUT. I FELT THERE WAS A REAL LANGUAGE BARRIER.... HM. WELL I'M KIND OF GLAD I'M NOT INTO IT, THERE ARE CERTAINLY BETTER GALLERIES IN PARIS PLUS I NEED SOME MORE TIME IN THE STUDIO.... ...

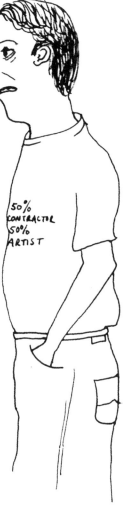

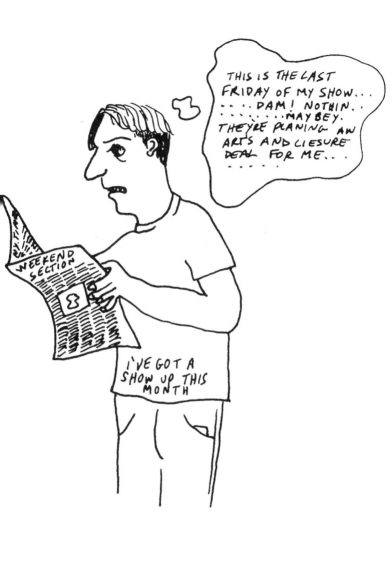

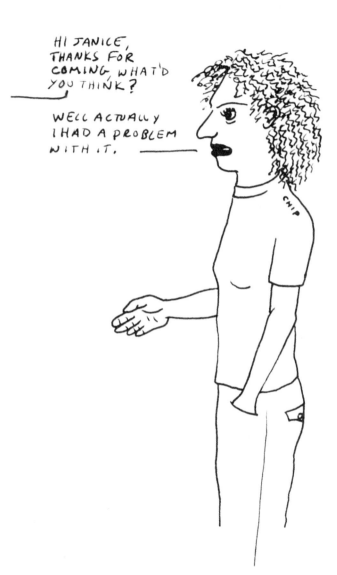

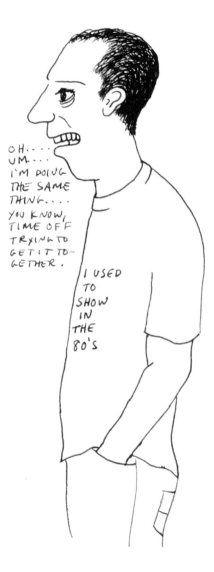

WELL AFTER
DOCUMENTA
I JUST HAVE
TO TAKE A
LITTLE TIME
OUT AND GET
MY HEAD ~~ANY~~
TOGETHER,
YOU KNOW?
LIKE WOAH!
I'M SO FUCKIN
BUSY...SO,
WHAT
DO YOU HAVE
COMING UP?

OH....
UM....
I'M DOING
THE SAME
THING....
YOU KNOW,
TIME OFF
TRYING TO
GET IT TO-
GETHER.

I USED
TO
SHOW
IN
THE
80'S

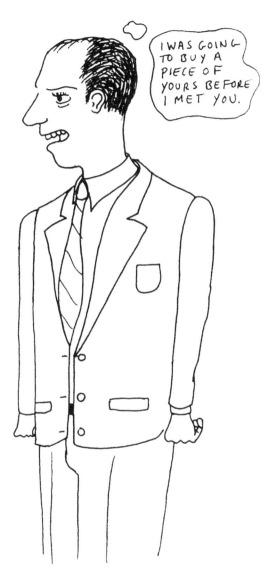

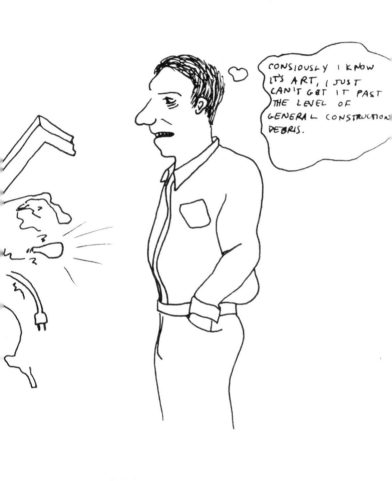

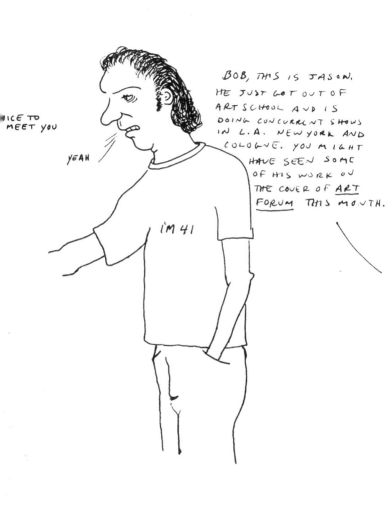

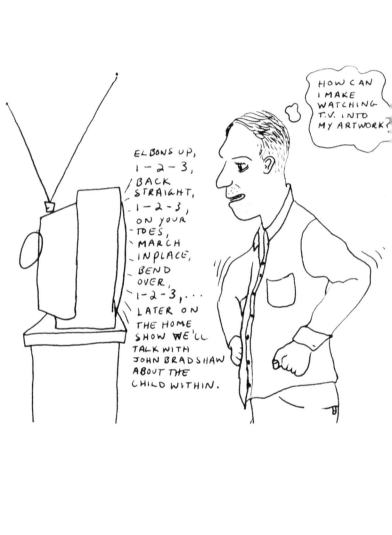

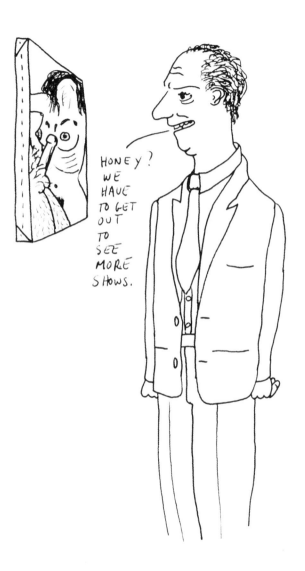

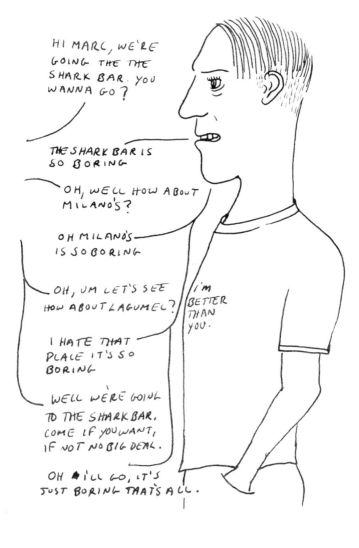

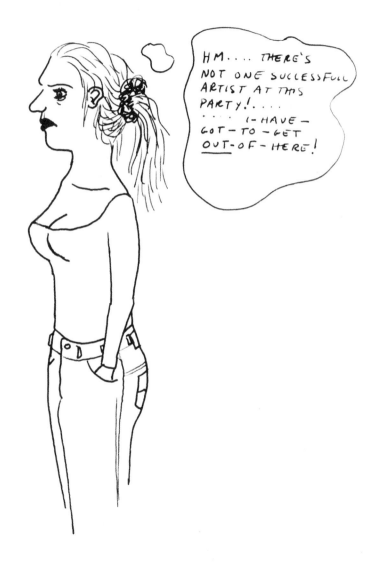

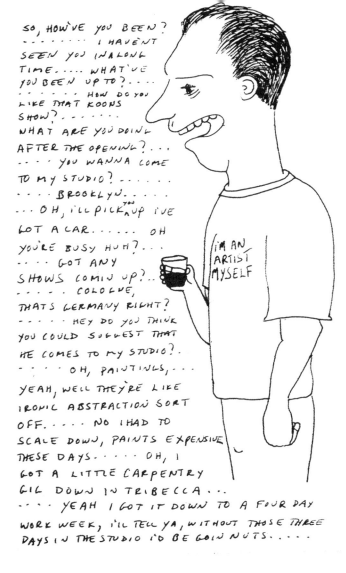

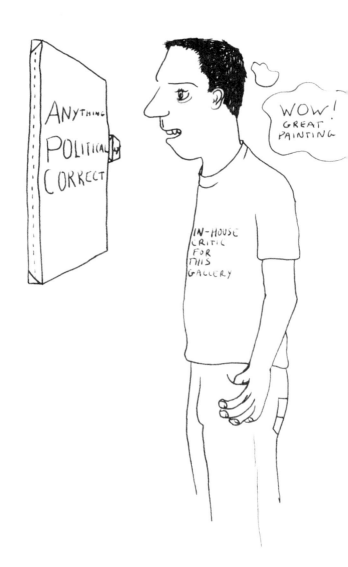

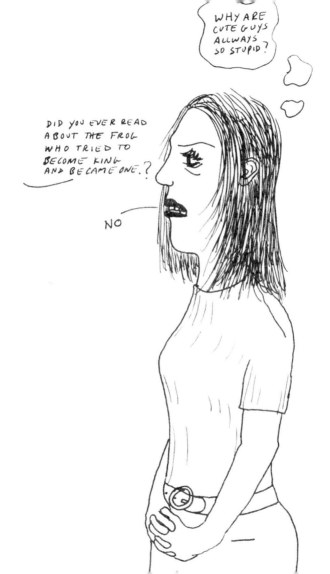

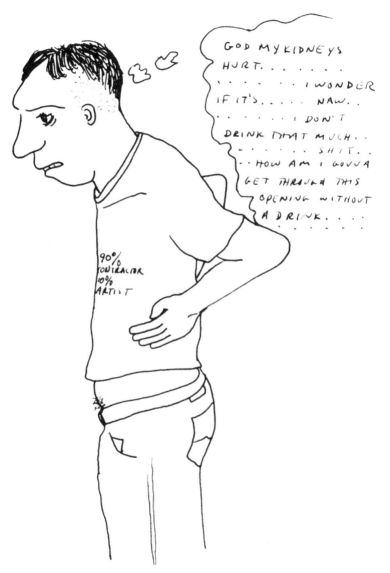

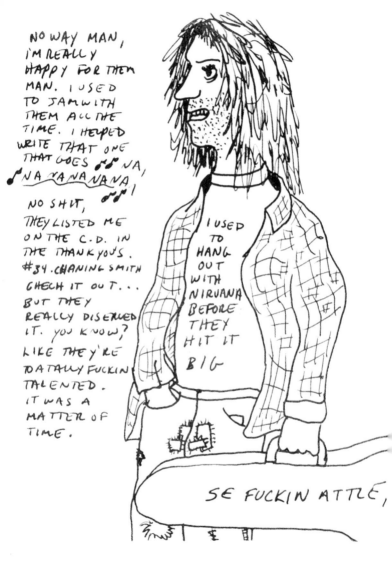

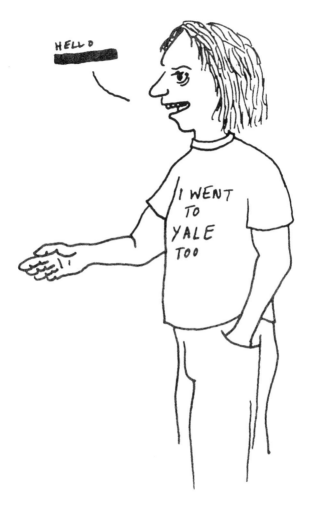

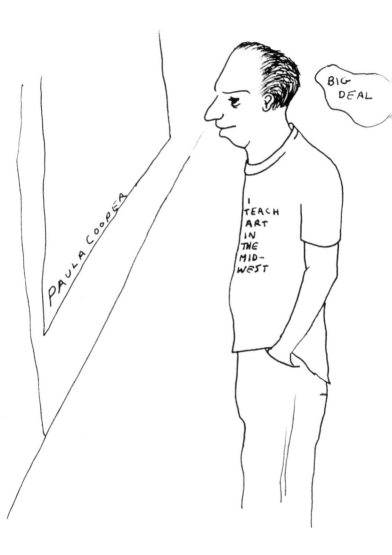

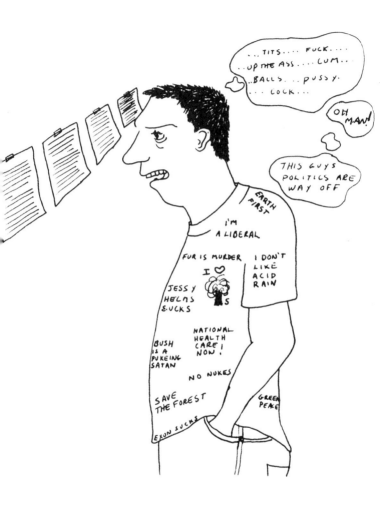

I DID NOT SAY THAT.
I DID NOT SAY THAT!!
HE IS A GOOD ARTIST
IN MY OPINION. THIS
JUST IS'NT HIS
BEST SHOW. IT'S
ENTIRELY TOO SELF-
OBSESSED. I JUST
DON'T THINK THAT THE
FIRST FEW SHOWS A
YOUNG ARTIST DOES ARE
NESASARILY GOING TO
BE THE BEST ONES.
LETS SEE AFTER TEN
YEARS HOW HE'S DOING.
IN TWENTY YEARS WILL
HE HAVE THE SAME
VITALITY?
. . . . NO JASPER JOHNS
IS A BAD EXAMPLE. . . .

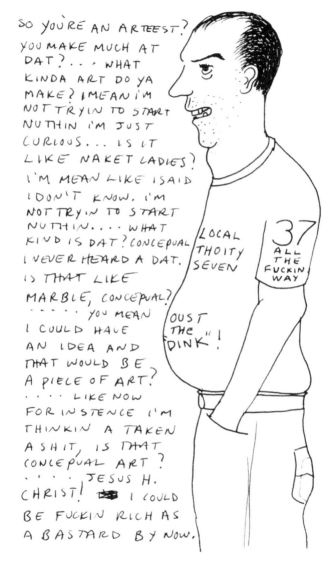

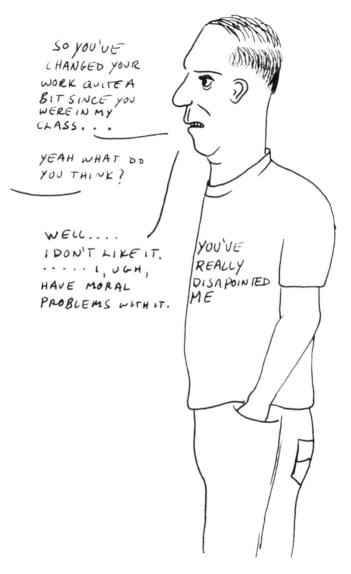

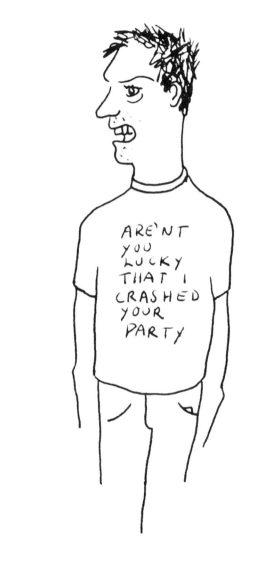

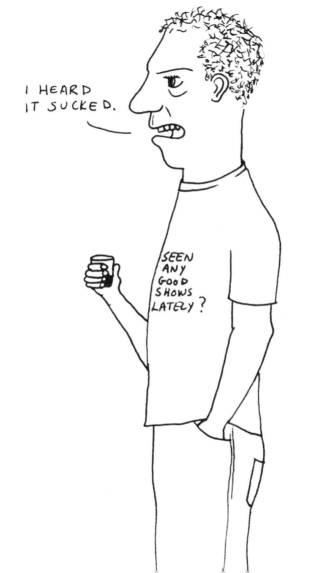

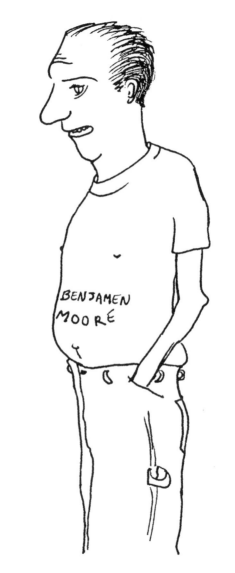

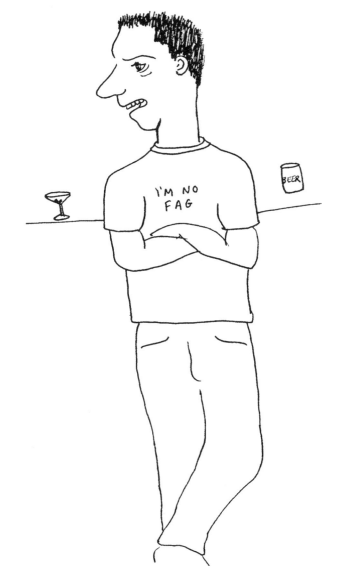

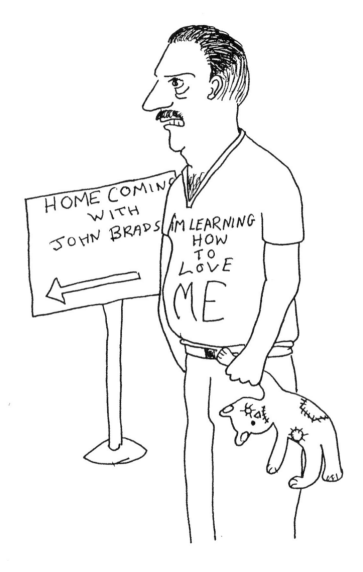

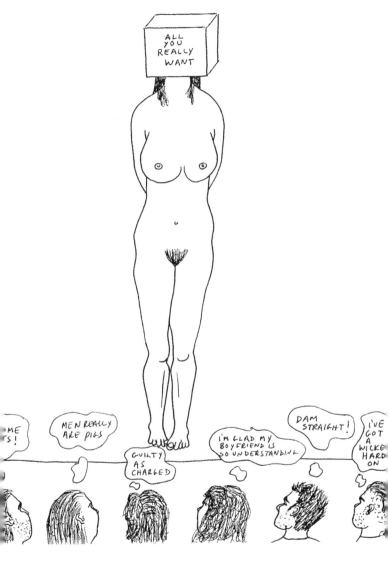

WELL IT'S PROBABLY ON ACCOUNT OF MY HEIGHT, YOU SEE IT'S ~~NOT~~ BECAUSE OF MY SIZE, YOU KNOW I'M SO LARGE. AND WHEN PEOPLE ARE CONFRONTED WITH A PERSON THAT IS SO TALL, WELL I DON'T KNOW THEY'RE JUST NOT USED TO SOMEONE AS BIG AS I AM. IT'S AS IF I WAS A GIANT OR SOMTHING. IT'S SO SILLY I'M NOT THAT HUGE.

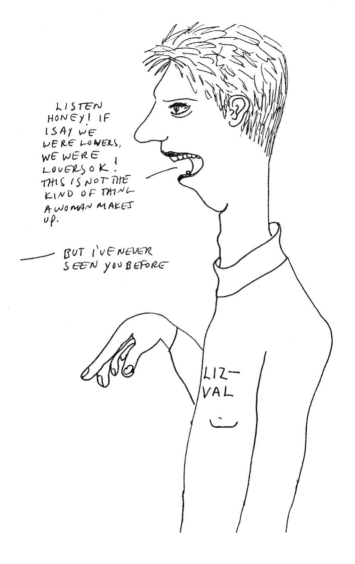

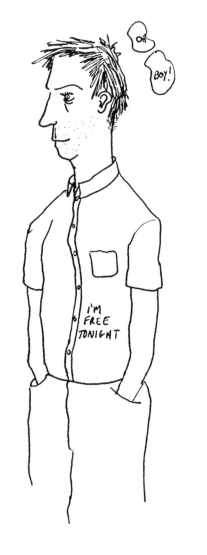

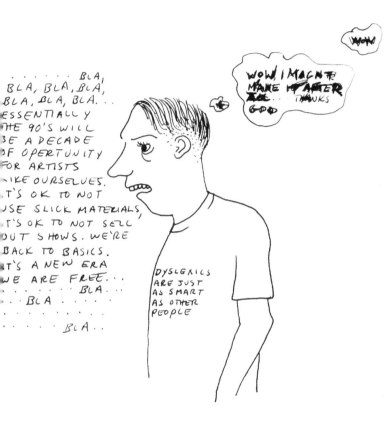

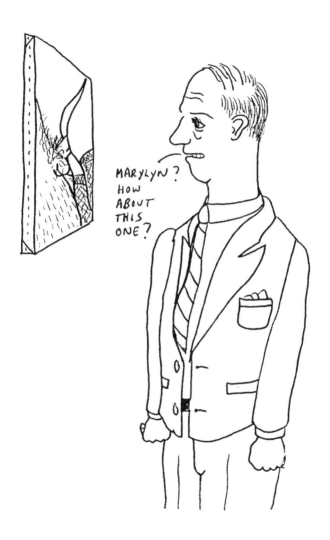

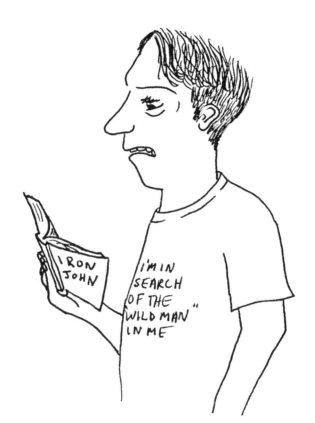

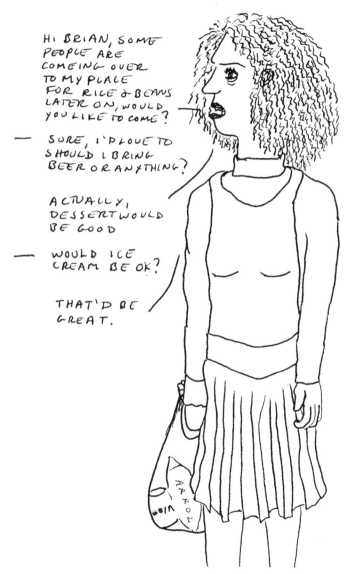

BETTER LUCK
NEXT TIME
LAR

SEE YOU
LATER LARRY
WE CAN'T JOIN YOU
FOR DRINKS TONIGHT
WE HAVE TO WORK
TOMORROW

THIS IS BE
THAN YOUR L
SHOW THAT
DID'NT SEL

CONGRATS
LARRY
IS THERE A
DINNER FOR
THIS ~~ART~~
OPENING

BYE
LARRY

NICE
SHOW
LAR

HELLO LARRY
WE WERE WONDERING
.F WE MIGHT USE YOUR
INVITATION IN OUR PUBLICATION
IT'S CALLED
LIZ-VAL.

THANKS

GREAT TO
SEE YOUR
NEW WORK
LARRY

GOOD
LUCK

HEY
THIS IS
REALLY
WIERD
STUFF

LARRY THIS
IS MY COUSIN
ELMO HE'S FROM
OUT OF TOWN BUT
WANTED TO MEET YOU

LARRY ID LIKE
YOU TO MEET THE
CURRATOR FROM
THE MUSEUM IN
BARROW ALASKA

HEY LARRY
I DON'T SEE
YOUR PARENTS
HERE, ARE
YOU TOO EMBARAS
TO LET THEM
COME

DO YOU STILL NEED
WORK LARRY? I'VE
GOT A SHEETROCK
JOB YOU
MIWAT BE INTERESTED
IN.

I LIKE YOUR
STUFF
LARRY

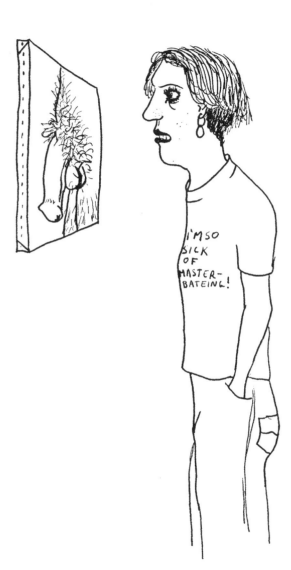

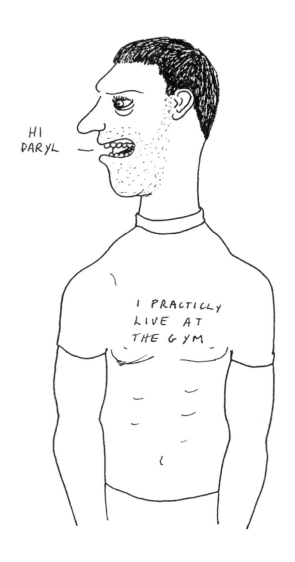

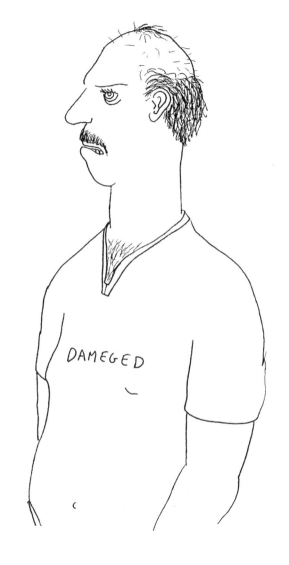

WELL MY LAST
GIG WAS AS
AN EXTRA
IN STARLIGHT
EXPRESS, THAT
WAS BEFORE
I PUT ON ALL
THIS WEIGHT.
THIS YEAR I'M
DEFINATELY
JOINING A GYM.

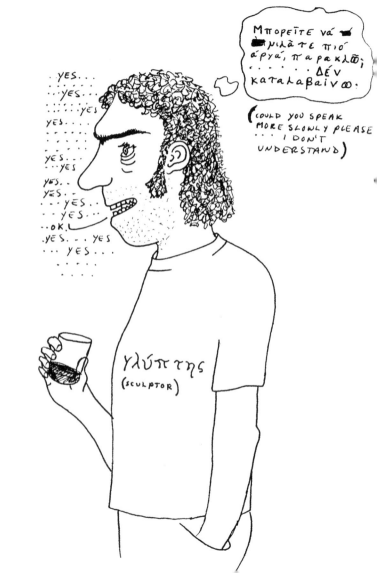

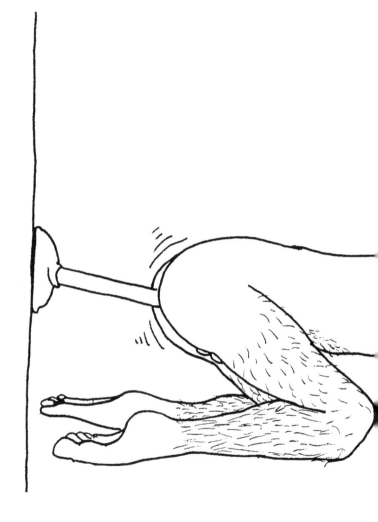

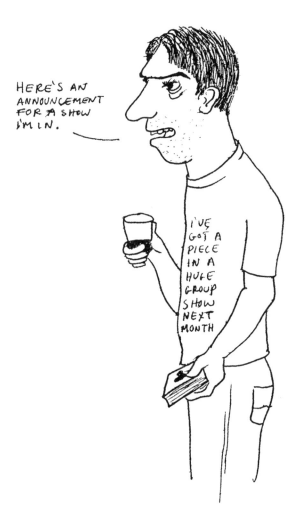

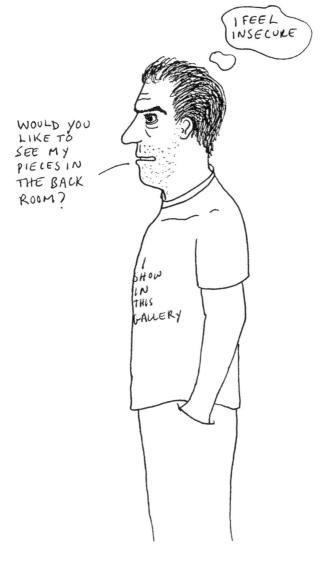

REMEMBER:
IT'S NOT YOU
THAT'S BAD
IT'S YOUR
WEIGHT THAT'S
BAD. TAKE A
COUPLE OF DAYS
AND CHOOSE THE
WEIGHT LOSS
PROGRAM THAT'S
BEST FOR YOU.

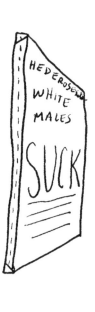

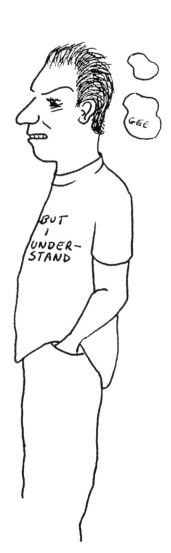

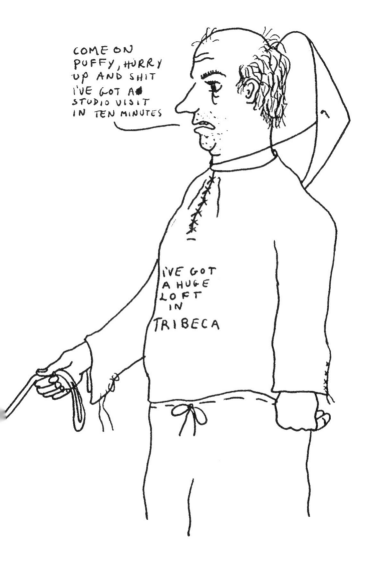

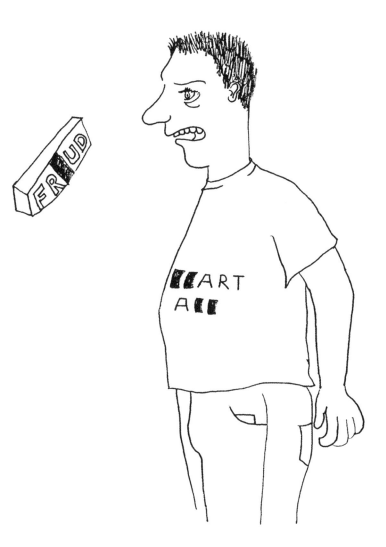

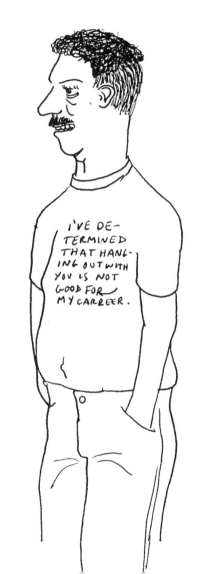

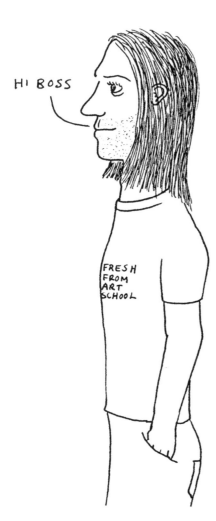

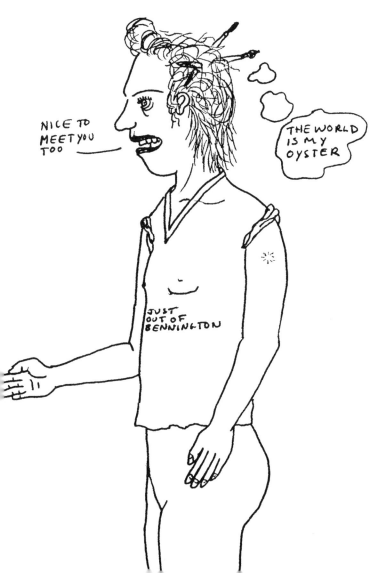

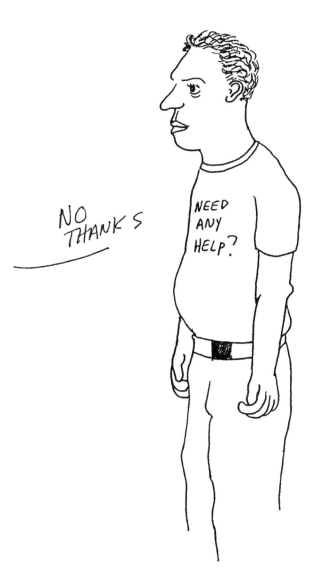

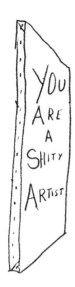

YOU ARE A SHITY ARTIST

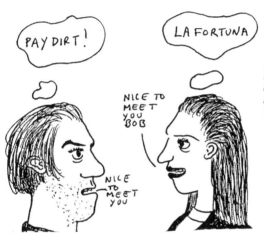

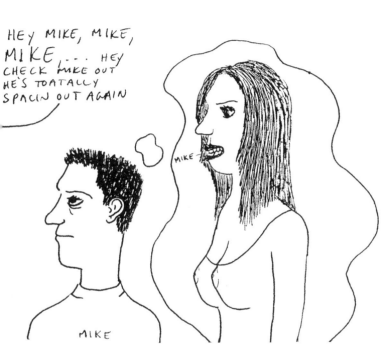

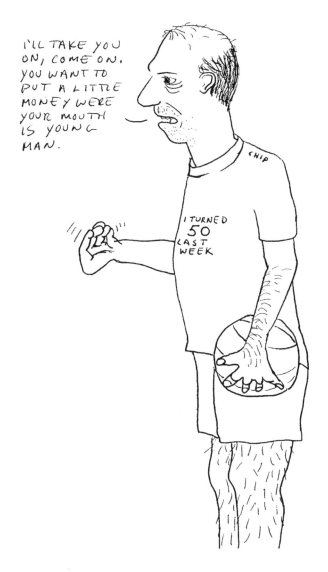

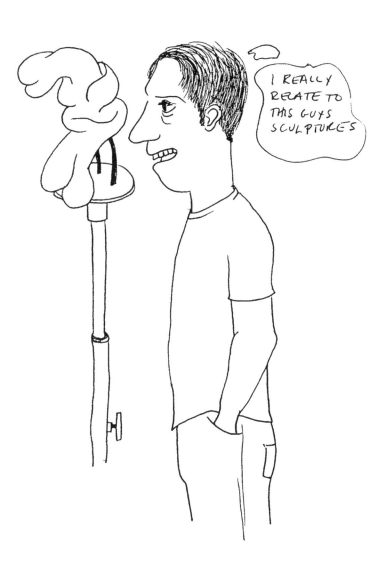

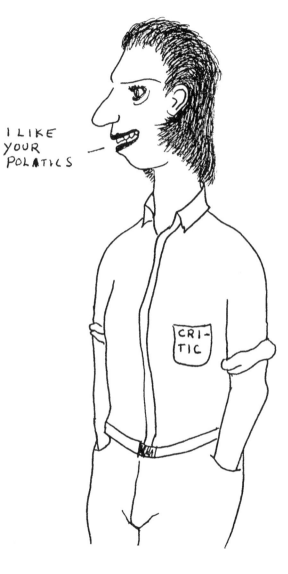

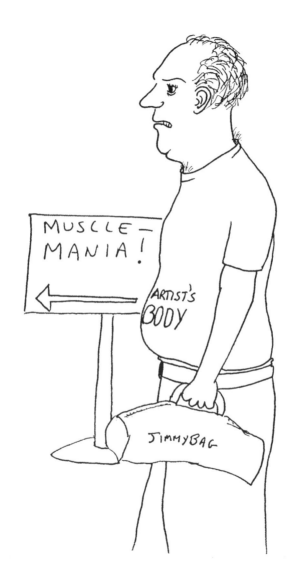

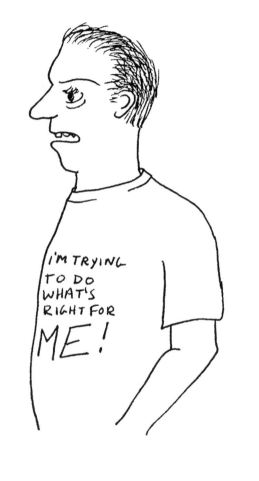

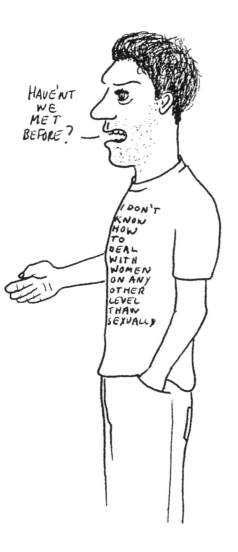

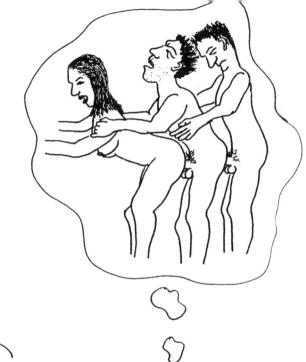

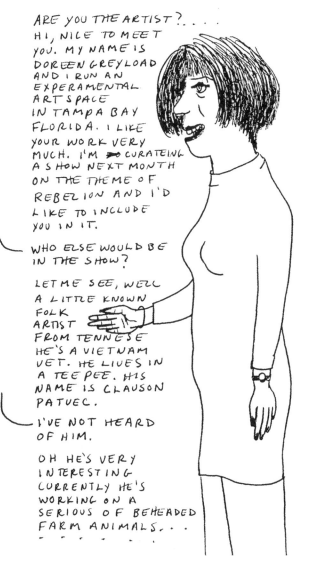

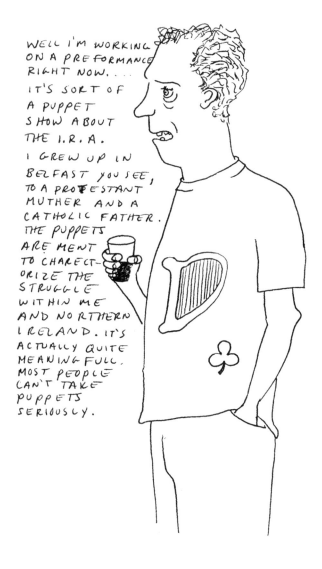

WELL I'M WORKING
ON A PREFORMANCE
RIGHT NOW....
IT'S SORT OF
A PUPPET
SHOW ABOUT
THE I.R.A.
I GREW UP IN
BELFAST YOU SEE,
TO A PROTESTANT
MUTHER AND A
CATHOLIC FATHER.
THE PUPPETS
ARE MENT
TO CHARECT-
ORIZE THE
STRUGGLE
WITHIN ME
AND NORTHERN
IRELAND. IT'S
ACTUALLY QUITE
MEANINGFULL.
MOST PEOPLE
CAN'T TAKE
PUPPETS
SERIOUSLY.

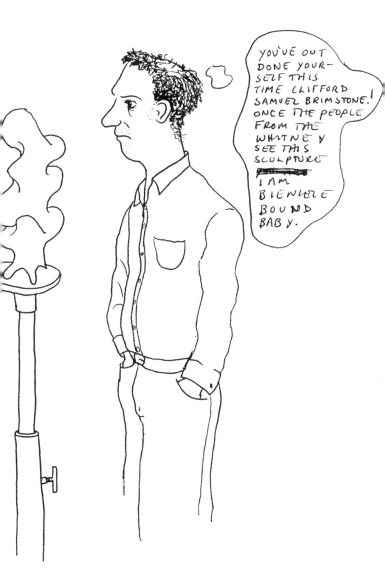

HI YOU MUST BE THE GUYS THE LANLORD SENT UP TO FIX THE SINK... JUST PUT YOUR TOOLS DOWN THERE... I TELL YA, I'VE HAD SUCH A HECTIC DAY. I'M ONLY HALF DRESSED.... TELL YOU WHAT! TAKE A SEAT THERE AND I'LL BE WITH YOU IN A MINUET.

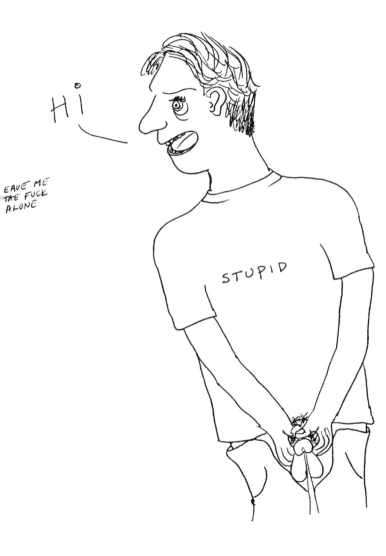

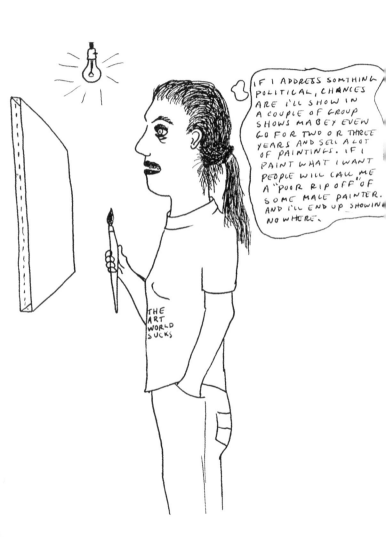

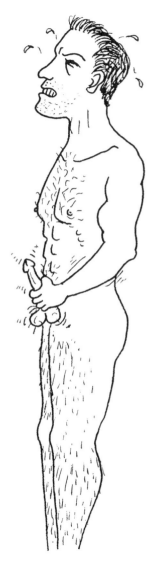

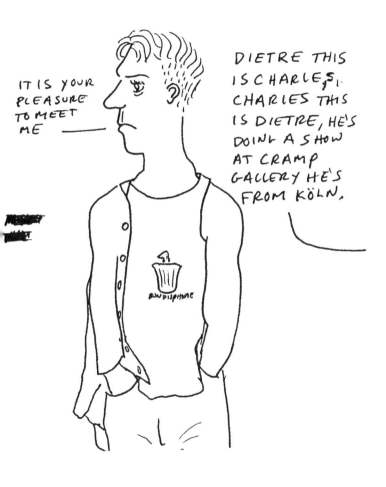

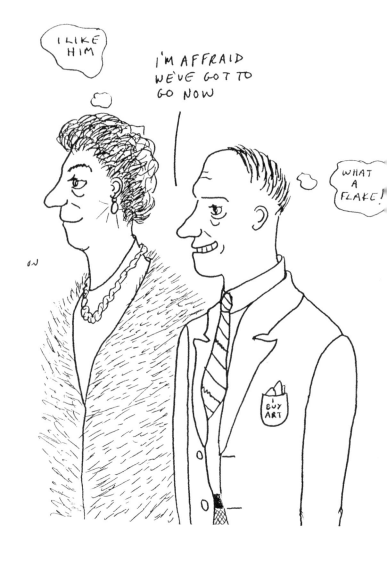

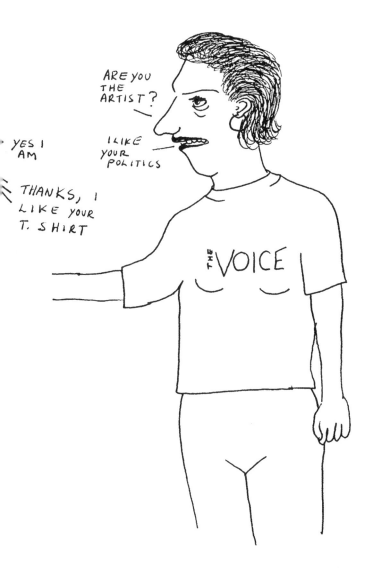

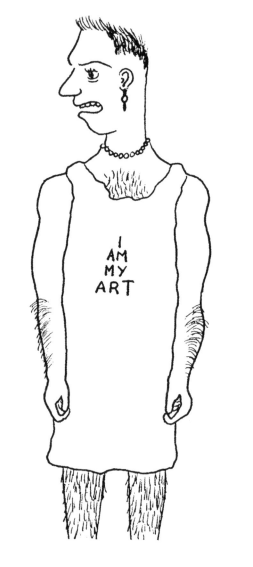

I SAW SOME TASTY
I. BEAMS OVER DA
B.Q.E. DEE OTHER
DAY. I'D GET UM MY
SELF BUT I NEED A
HAND PUTTIN EM ON
MY TRUCK. THERE'S A
LUNCH IN IT FOR YA
IF YOU COME HELP ME.
. OH YOU'RE IN
DIS SHOW? YEAH MY
WIFE'S GIRLFREIND'S IN
IT TOO. SHE DID THOSE
DOLL CLOTHING PIECES . .
. . . . YEAH, WELL IT'S
ACTUALLY MENSTRAL BLOOD
. BETWEEN YOU AND
ME, I'M GLAD THE ONLY SEX
ORGAN I GOT'S HANGIN BETWEEN
MY LEGS, WHICH REMINDS ME
IS THERE A PISSER AROUND
HERE?

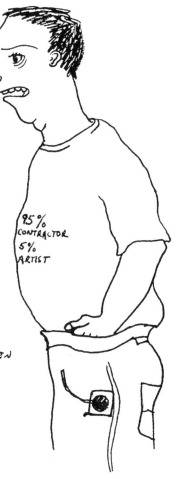

I KNOW WHAT YOU'RE SAYING MAN, I'M SO FUCKIN SICK OF WORKING. I CONSCIOUSLY FUCK JOBS UP. I HATE IT! HERE I AM WORKING AND I'VE GOT THAT GROUP SHOW IN COLOGNE AND THAT ONE MAN SHOW IN L.A. ALL THE WORK HAS TO BE DONE BY THE END OF THE MONTH AND I'M TOTALLY FUCKIN BROKE. NO THAT WAS A THING OF THE PAST. DEALERS DON'T GIVE ARTISTS MONEY ANYMORE. IT'S TRUE! WHY DO YOU THINK YOU'RE SEEING SO MUCH "JUNK ART" THESE DAYS?. I'LL TELL YOU IT ALL SPELLS SINGLE TERM PRESIDENCY FOR BUSH. SURE, 1968, BIRTH OF SCATTER ART. LYNDON JOHNSON "OUT A THERE" 1992, "NEO SCATTER" BYE BYE BUSH.

60% ARTIST 40% CONTRACTOR

OH YEAH ? WELL MAYBE YOU KNOW MY BROTHER HE WENT TO SCHOOL OUT THERE TOO. NO HE HAS BROWN HAIR, BROWN EYES. HE'S ABOUT 5'10" HE WERE'S CLOTHSE LIKE I'M WEARING NOW. HE LOOKS ALMOST EXALTLY LIKE ME. EXLEPT HE DOES'NT HAVE A MOUSTACHE. IT'S A FAMILY TRA-DITION TO WEAR FACIEL HAIR. OF-COURSE MY BROTHER IGNORSE IT. I'M JUST EXPIERAMENTING WITH THE SIDE BURNS. DO YOU KNOW OF ANY GOOD PARTIES TONIGHT? I HEARD THAT THERE MIGHT BE A PARTY CRAMP FOR THE ~~CRAMPS~~ SHOW. I DON'T KNOW MAYBE I'LL JUST SHOW UP. NOBODY WILL KNOW I WAS'NT INVITED.

DANIEL YOU LOOK FABULOUS YOU MUST BE DOING WHAT'S "RIGHT FOR YOU"

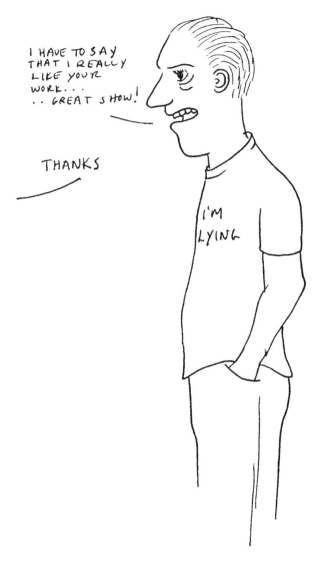

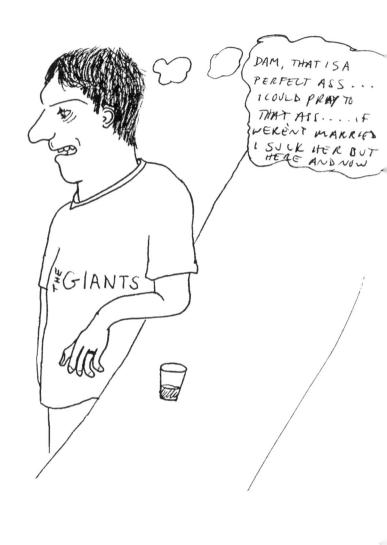

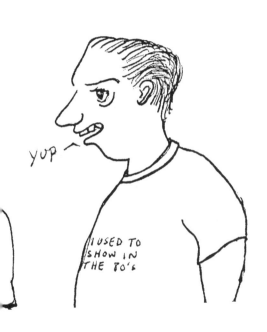

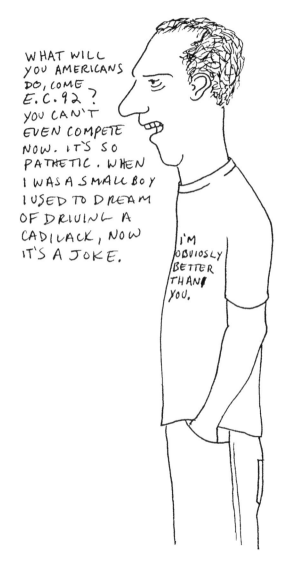

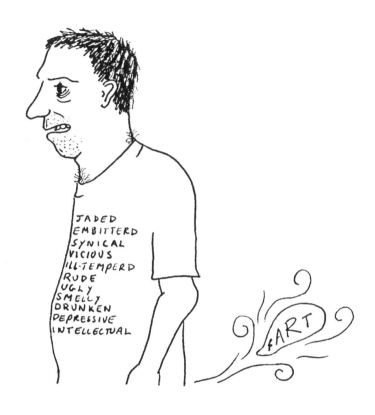

Sean Landers
Cartoons
ISBN 0-9749037-4-4

These cartoons were made in the winter of 1991-92
and shown at the Andrea Rosen Gallery in 1992.

Regency Arts Press
P.O. Box 20403
New York NY 10011
Telephone: 212-243-7104
www.regencyartspress.com
info@regencyartspress.com

Design: Omnivore, Inc.